It is said that [the]
journey starts with the
first step — Thank
you Linda for helping
get started. The world
is opening up to this
forty four year old
"baby/woman". This
workshop was a
wonderful experience
for me. enjoy.

Peggy Walleen

With deepest &
warmest affection,
Vicki

very
much
a
woman's
book

by
peggy warren

published by:

Art After Five
P.O. Box 247
Nederland, CO 80466

copyright 1989 by Peggy Warren
fourth printing

Library of Congress
Catalog Number: 93-090411

dedicated
 to the inner voice
 in all of us

with Special thanks to Maude Meehan for her thoughtful editorial contribution, and to Michael Warren for his personal handwriting and design expertise.

contents

living 9

loving 27

letting go 47

I travel through
the pages
of my life

wanting to
bring to you
a part of me
to share

So many ways
we are alike
but
feel
so
different

Somewhere in
these lines
may we share
a truth

Living

word coloring
coloring words
word pictures
pictorial verbs
moments remembered
remembering times
wonderfully woven
wovenly rhymes

You come into my life

 Sunshine filtering through
 a dense forest
 A ray of light bouncing
 filling my darkness
 with sweet surprise

I run to follow the light

 fearful it will not last
 tripping in my haste

Not knowing that light
is all around me

 My own light

 even in darkness

Being twenty is
thinking it's all ahead
Being forty is
thinking it's all behind
Being fifty is
knowing it's neither

Youth
 is wasted on the young

If that's the case
let's unite
take it from them

We'll give them
 some
of what's ours
in return

 like

 experience
 wisdom
 knowledge
 memories

Hey, wait a minute

 NOT SO FAST!

My mind takes me
places I'd never
dare go
if given a chance
to say yes or no
One moment I'm
dancing in gardens
of dew
The next it's a
dungeon with hell
for a view
The choice isn't
mine
I go where I must
The only solution
is simply to trust

She goes through her days

 being
 what everyone wants
 doing
 all that's expected

Her soul struggles

 unable to release
 the bondage
 she has created

Wrapped
 in the service of others

Happiness is
wafting over my being

 sending silent rushes
 of pleasure shivering
 through me

From where does it come
Why is it not here
 on demand

Let me not question

 but rather savor the
 elusive sensation

writing can be
silly stuff
powder puff
made of fluff
eiderdown
royal crown
very pompous
cir cum staunceous
always playing
sometimes laying
oops! that's naughty
am I dotty
yes I'd say so
then I'd say no
only silly
yes that's all

My life is filled
with magic today

 down filled lie-me-downs
 moon flavored ebony water
 rippling

colored tulips
aching in their
openness

Life is
more
than clapboard
houses and
gray lampposts

 Looking through the window
 I am released from things
 and places

 and sometimes me

An extension of myself over
which I have no control

That is my grown up child
floundering through life
with my guts attached

I do not ask for such a ride
but in open caring I leave
myself to chafed wounds

Only in raw relentless support
can I help the awkward struggle
turn from floundering to strength

'Why' is a word that
puts shackles on glee
I don't want to own it
It's strangling me

We grew up

 thinking the music
 would never stop
 dancing our way
 into middle age
 with wailing babies
 puberty and braces
 high school proms

 not prepared
 for soundless days
 spilling into
 empty nights

 burying us
 in the silence
 of forgotten dreams

 smothered
 by the helplessness
 of lost purpose

Time our only hope
 for the release
 of music suffocated
 by surrendered years

In the silence
 precious sound returns

As the music swells
 so does the meaning

 This time
 for ourselves

rain
means
quiet times
mellow moments
mingling with
lazy thoughts
tranquil music
log burning
solitude
lovers
lingering
sharing
uninterrupted
laziness

Loving

We need to share
more of what we are
in order to make
what we are more

How I choose to see love
is how it is

The choice is mine

How dare I sabotage
the joy I can bring

myself
and others

by viewing love wrapped

in judgment

and fear

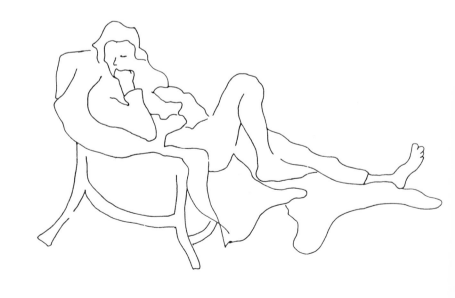

Deep inside you travel alone

I have wanted so much
 to be a part of those travels

But now I know that place
 not mine not ours

 but yours

My place in your life is different
from what I hoped
 and dreamed

It has no clarity for me right now

But I can tell from the look
 in your eyes
 and the feel
 of your touch

that my place in your life is important

Just knowing that will have to be

 enough for now

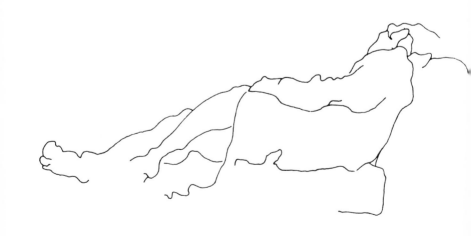

Sometimes at the first light of dawn
 when I awake
all the fears of my life come
 to haunt me
and I turn from the love that I want

Sometimes when I long to reach out
 and embrace you
all the hurts from the years
 rise to choke me
and I run from the love that you give

Sometimes at the last sound of life
 in the evening
all the tears of my childhood
 swirl around me
and I hide from the love that I need

Please understand
 Don't leave

If who I am
is wrapped up
in who I want you
to think I am
how can you
know me

The white car pulled away
 with you in it

I stayed behind expecting
 to be sad
because so much of me
 is wrapped up in you

 or so I thought

Instead
 a huge black cloud lifted
 leaving a mirthful spirit

 where before
 had been a dutiful wife

I am not dutiful by choice
 but by habit

Am I allowed to be mirthful
 and married too?

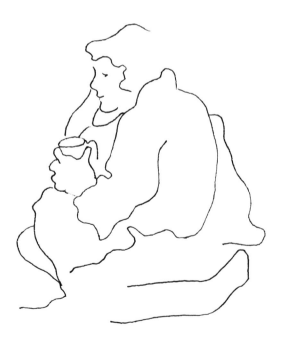

You listen
 but do not hear

Speak
 but do not share

 because you are afraid

 "BULLSHIT!" you say
 "Afraid of what!"

 Afraid that I will see you
 and you will feel a need
 to cry

Trust that through your
tears you will finally
be able to see

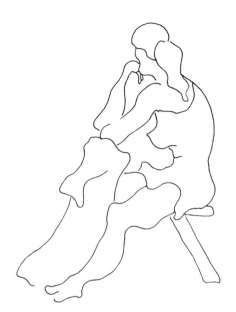

I needed to let you go
 to keep you

To free myself
 so I could free you

 "Crazy!" you say
 "What kind of language is that!"

 "Simple" I say

The language of making life work

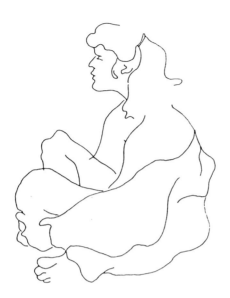

I wrap my arms around you in wonder

wonder that you could love me
 when I have crushed your love
 (I guess that's called growing)

 wonder that you can open
 when I have closed
 the door on your soul
 (I guess that's called growing)

 wonder that you can forgive
 without question
 without needing to understand
 (I guess that's called loving)

May I be blessed enough to grow in your love

Joy is magic
moments shared
people giving
of each other
replacing
darkness
with light

I've chosen to be here
 rather than there

I've chosen to be with you
 rather than alone

(How strange I needed
to be there to know that)

I wind around you loosely
 kiss you softly

There is nothing left to fear

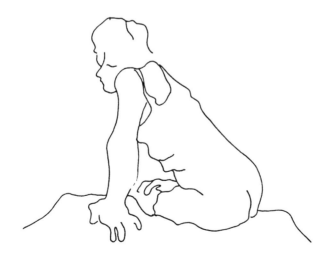

You bring to me my life

unfolded

Hidden corners open
to the morning light

The sun casts reflections
and the shadows are
free of fear

I dance in gossamer
as the weight of
leaden layers is lifted

The gentle breeze of life
wafts over me

The push against
the storm has ceased

I think I'm learning
the way to be free
not through others
only through me

letting go

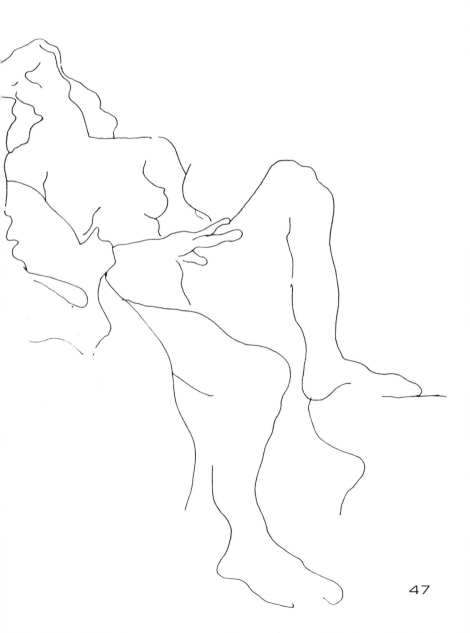

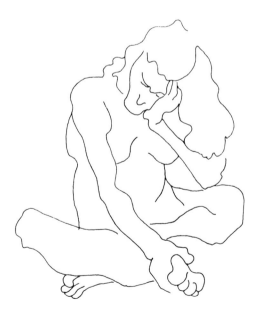

We're little girls
 in grown up
 birthday dresses

blowing out
 the candles
 of our lives
 with secret wishes
 held inside our hearts

Let go the wishes

 and the dreams
 of blown out candles
 will turn the birthday
 dresses into gowns of lace

Lessons learned
are fleeting moments
of inspiration

 painted
 on the canvas
 of my life

I choose the colors
for my palette

 taking care
 to keep from
 muddying
 the masterpiece

that is me

The waters of my mind
spill forth their contents

An endless rush

Sorting sweet from sour
magic from mayhem
leaving me baffled

So much time
So many memories

Spill forth!

I will no longer dam
the needed flow for
when the hour is over
floodgates slam

Time has gone for spilling

words pour
into sentences
born of messages
from the soul

To hurt meant simple things
when I was little

 like knee scrapes
 or
 waking from a scary
 nightmare

when I was bigger

But now

To hurt means gut rotting pain
clawing at my soul
 a vulture

 The stench of helplessness

I seek but darkness hides my path
Hide but shadows fill my dark

There is nowhere left to go
Nothing left to do

 Only time can help

Sometimes I weep for
all the things that
aren't in my life

 all the fragmented
 moments gone awry

Then I dry my tears

 I will not cry for
 moments of learning

It's a matter of time
so what do you care
about losing your looks
or even your hair
You might as well hurry
the process along
so you'll have time to enjoy
what's left when they're gone

My friend:

> I have left a part of me
> spilled upon your floor
>
> like tiny glass beads
>
> > Tread lightly

We set ourselves
in boxes too small
to be together even
with ourselves

His sadness sweeps
across the empty park
denying me the solitude
I've come to seek

I raise my head and catch
the moment he would surely
hide if only he could

Sometimes pain
will not be silenced

He turns away
as if to say be still
 to both of us

I bow my head
Let him know
 I'll not intrude

We enter into the flow of life draped in silk
immediately donning armour to fight our way

 m
 a
 e
 r
 t
 s
 up

Why must we battle the tide
scarring ourselves on peaceful rocks

 before we finally
 understand the
 flow is

 down
 s
 t
 r
 e
 a
 m

Rocks are stepping stones
resting places when the flow is too fast

 armour impedes
 silk enhances

Surrender to the flow of life enhanced

help me to know
the lessons
of the past
so I can
be in harmony
with the present

My life unfolds a series
of reflective blendings
a symphony that swells
within this vibrant spirit

The melody unclear
The story still untold
Crescendos swirl as
notes of life play on
beneath my flesh

The mirror does not lie

but
sends
back
images
from
the
soul come to
 etch our stories
 into the surface
 of our flesh

Years
carve
labyrinths
of
broken
dreams each a pattern of a
 time gone by

Crevices
increase
with
haste until we learn
 that stories are
 the made up way
 we live our lives

A birth day of memories

 Some too sad to keep the pages open
 Others filled with laughter and joy
 their images dancing circles
 around your heart

Join hands
 with all the parts
 that are you this day

 The preparation over
 Only the party remains

sitting
silently
splendidly
savoring
serenity

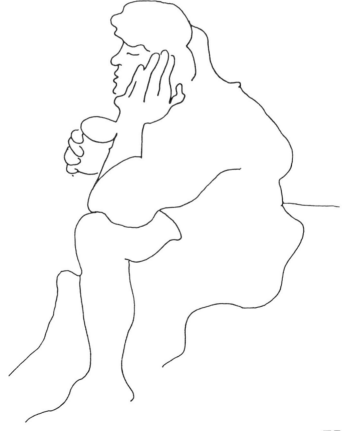

73

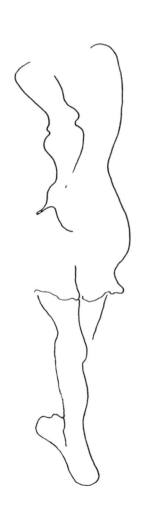

We come alone
 We leave alone

 In the void
 of empty pages
 we imprint
 the message
 of our lives

to leave to
 those who care